Writers · *Écrivains* · Schriftsteller

Photographs of Magnum Photos · *Photographies de Magnum Photos* · **Fotografien von Magnum Photos**

·TERRAIL·
P H O T O

■ Editor: Jean-Claude Dubost
Desk Editor: Caroline Broué in liaison with Magnum Photos' team
Cover design: Gérard Lo Monaco and Laurence Moinot
Graphic design: Véronique Rossi
Iconographic and artistic coordination at Magnum Photos:
Marie-Christine Biebuyck, Agnès Sire, assisted by Philippe Devernay
English translation: Ann Sautier-Greening
Photoengraving: Litho Service T. Zamboni, Verona

© FINEST SA / ÉDITIONS PIERRE TERRAIL, Paris 1998
The Art Book Subsidiary of BAYARD PRESSE SA
© Magnum Photos, Paris 1998
ISBN 2-87939-161-X
English edition: © 1998
Publication number: 198
Printed in Italy
All rights reserved.

■ Direction éditoriale : Jean-Claude Dubost
Suivi éditorial : Caroline Broué en liaison avec l'équipe de Magnum Photos
Conception et réalisation de couverture : Gérard Lo Monaco et Laurence Moinot
Conception et réalisation graphique : Véronique Rossi
Direction iconographique et artistique à Magnum Photos :
Marie-Christine Biebuyck, Agnès Sire, assistées de Philippe Devernay
Traduction anglaise : Ann Sautier-Greening
Traduction allemande : Inge Hanneforth
Photogravure : Litho Service T. Zamboni, Vérone

© FINEST SA / ÉDITIONS PIERRE TERRAIL, Paris 1998
La filiale Livres d'art de BAYARD PRESSE SA
© Magnum Photos, Paris 1998
ISBN 2-87939-159-8
N° d'éditeur : 198
Dépôt légal : mars 1998
Imprimé en Italie
Tous droits réservés pour tous pays.

■ Verlegerische Leitung: Jean-Claude Dubost
Verantwortlich für die Ausgabe: Caroline Broué
in Zusammenarbeit mit dem Magnum Photos Team
Umschlaggestaltung: Gérard Lo Monaco und Laurence Moinot
Buchgestaltung: Véronique Rossi
Bildredaktion und grafische Gestaltung für Magnum Photos:
Marie-Christine Biebuyck, Agnès Sire; Assistent: Philippe Devernay
Deutsche Übersetzung: Inge Hanneforth
Farblithos: Litho Service T. Zamboni, Verona

© FINEST SA / ÉDITIONS PIERRE TERRAIL, Paris 1998
Der Bereich Kunstbücher von BAYARD PRESSE SA
© Magnum Photos, Paris 1998
ISBN 2-87939-160-1
Deutsche Ausgabe: © 1998
Verlegernummer: 198
Printed in Italy
Alle Rechte vorbehalten.

"I walked around all day, my mind occupied, seeking on the streets photographs to be taken directly from life as if in flagrante delicto. I wanted above all to seize in a single image the essence of any scene that cropped up. [...] Photography is the only means of expression which freezes one specific instant", wrote Henri Cartier-Bresson, one of the founding members of the Magnum Photos Agency. During their assignments to the four corners of the earth, the photographers of this prestigious agency have all wanted to record a certain reality directly seized "from life" and to show the world as they saw and felt it. Their photographs bear witness to the experience of men, to places, times and events which their cameras have managed to capture. The personal imprint they leave on them proves, in the words of John Steinbeck, that "the camera need not be a cold mechanical device. Like the pen, it is as good as the man who uses it. It can be the extension of mind and heart...". The ambition of the series to which this album belongs is to recall the finest of these "decisive moments", where the eye of the photographer encounters the diversity of the world. Whether it is read like a report or looked at like a film, each album is above all a thematic, historic and aesthetic odyssey bringing together the best pictures from the Magnum photographers.

« Je marchais toute la journée, l'esprit tendu, cherchant dans les rues à prendre sur le vif des photos comme des flagrants délits. J'avais surtout le désir de saisir dans une seule image l'essentiel d'une scène qui surgissait. [...] De tous les moyens d'expression, la photo est le seul qui fixe un instant précis », écrivait Henri Cartier-Bresson, l'un des fondateurs de l'agence Magnum Photos. Les photographes de cette prestigieuse agence ont tous voulu, au cours de leurs reportages à travers le monde, rendre compte d'une certaine réalité « sur le vif » et montrer le monde tel qu'ils le voyaient et le ressentaient. Leurs photos témoignent de l'expérience d'hommes, de lieux, d'époques et d'événements que leur appareil a su capter. L'empreinte personnelle qu'ils laissent prouve, selon les mots de John Steinbeck, que « l'appareil-photo n'est pas nécessairement une froide mécanique. Comme la plume pour l'écrivain, tout dépend de qui la manie. Il peut être un prolongement de l'esprit et du cœur... » Restituer les plus beaux de ces « instants décisifs » au fil desquels l'œil du photographe rencontre la diversité du monde, telle est l'ambition de la collection dans laquelle s'inscrit ce livre. À lire comme un récit ou à regarder comme un film, il est avant tout une promenade thématique, historique et esthétique qui rassemble les meilleurs clichés des photographes de Magnum Photos.

„Den ganzen Tag lief ich angespannt herum, denn ich wollte in den Straßen wie auf frischer Tat ertappte, lebensnahe Fotos machen. Vor allem hatte ich den Wunsch, in einem einzigen Bild das Wesentliche eines Geschehnisses festzuhalten [...] Von allen Ausdrucksmitteln ist die Fotografie das einzige, das einen bestimmten Augenblick fixiert", schrieb Henri Cartier-Bresson, einer der Gründer der Fotoagentur Agence Magnum Photos. Den Fotografen dieser renommierten Agentur liegt viel daran, auf ihren Reportagen in aller Welt von einer gewissen „lebensnahen" Realität Zeugnis abzulegen und die Welt so zu zeigen, wie sie sie sahen und empfanden. Die Fotos sind von ihrem Apparat eingefangene Erfahrungen mit Menschen, Orten, Zeiten und Ereignissen. Der persönliche Eindruck, die sie hinterlassen, beweist, um mit Steinbeck zu sprechen, daß „der Fotoapparat keine kalte Mechanik sein muß. Wie bei der Feder des Schriftstellers hängt alles davon ab, wer sie hält. Und manchmal ist es sogar eine Verlängerung von Geist und Gefühl ..." Die schönsten dieser „entscheidenen Augenblicke" zu zeigen, bei denen das Auge des Fotografen der Vielfältigkeit der Welt begegnet, ist die Absicht dieser Buchreihe. Wie ein Bericht zu lesen oder wie ein Film zu betrachten, ist sie vor allem ein thematischer, historischer und ästhetischer Spaziergang, auf dem die besten Bilder der Fotografen von Magnum Photos zu sehen sind.

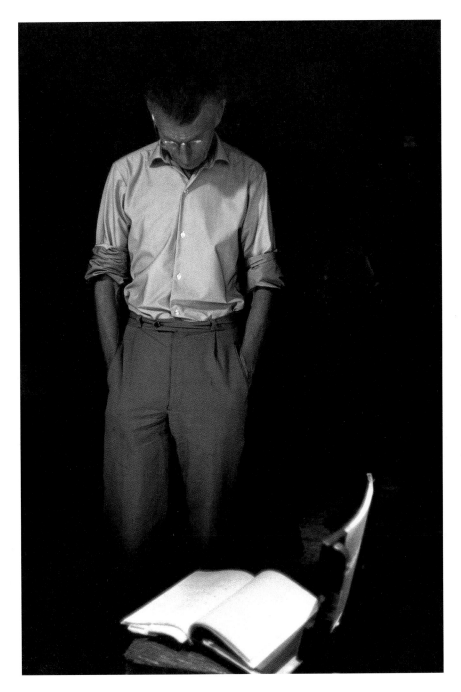

Bruce Davidson, USA, *États-Unis,* 1964. Samuel Beckett.

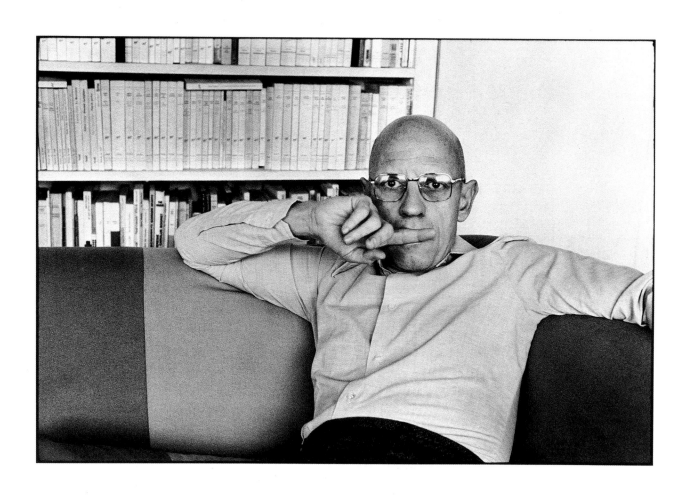

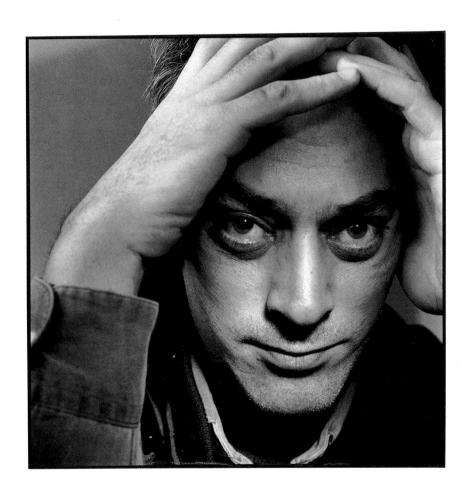

Bruce Davidson, USA, *États-Unis,* 1994. Paul Auster.

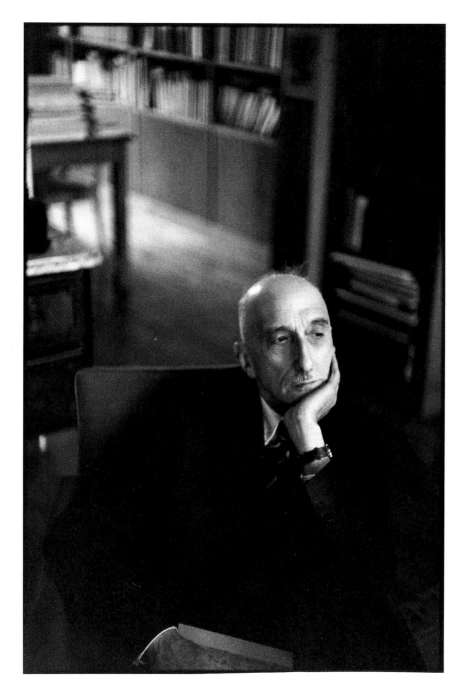

Henri Cartier-Bresson, *France, Frankreich,* 1952. FRANÇOIS MAURIAC.

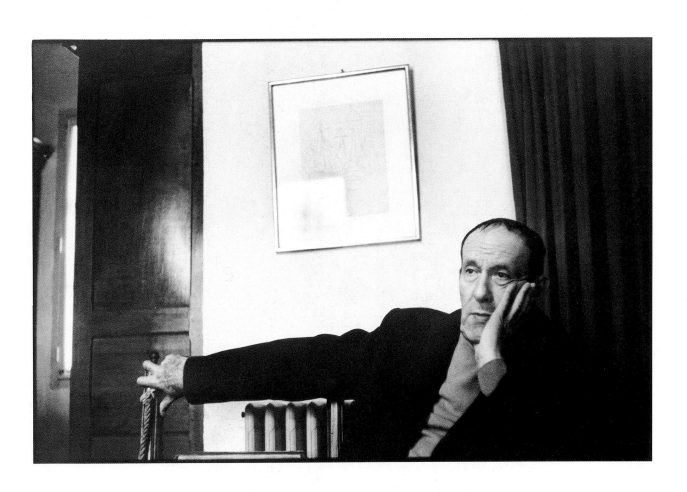

Henri Cartier-Bresson, *France,* Frankreich, 1977. RENÉ CHAR.

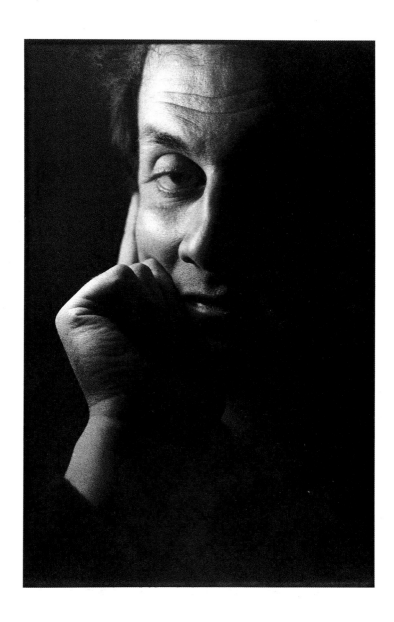

Gilles Peress, England, *Angleterre,* 1988. SALMAN RUSHDIE.

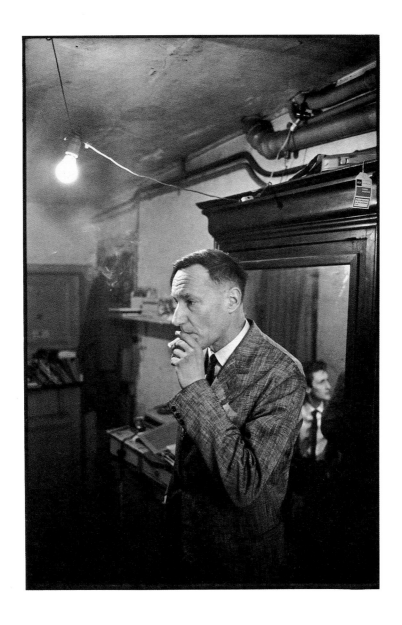

Nicolas Tikhomiroff, *France,* Frankreich, 1970. WILLIAM BURROUGHS. | **11**

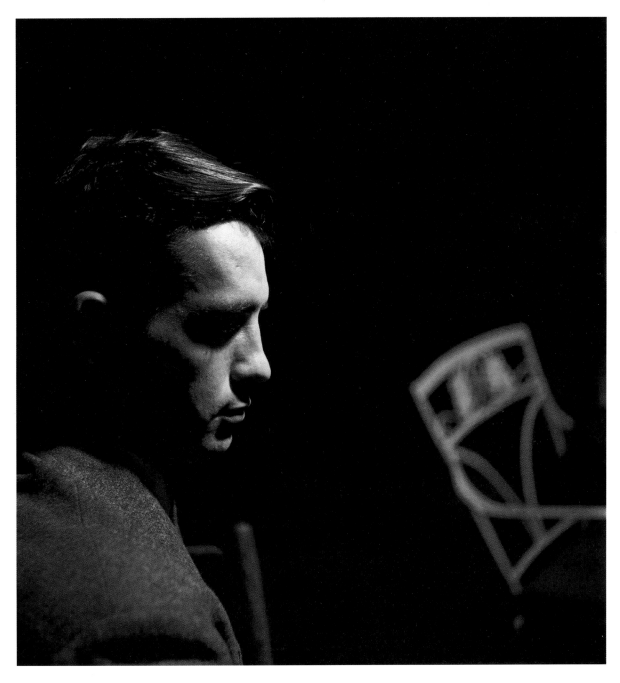

Elliott Erwitt, USA, *États-Unis,* 1950s, *années 50,* fünfziger Jahre. JACK KEROUAC.

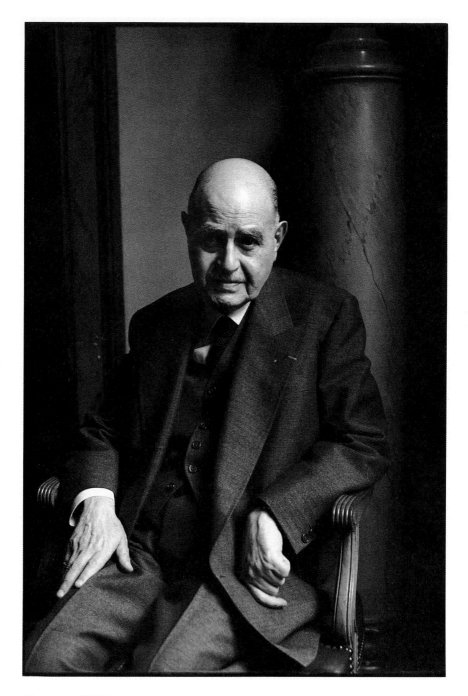

| Martine Franck, *France,* Frankreich, 1968. ALBERT COHEN.

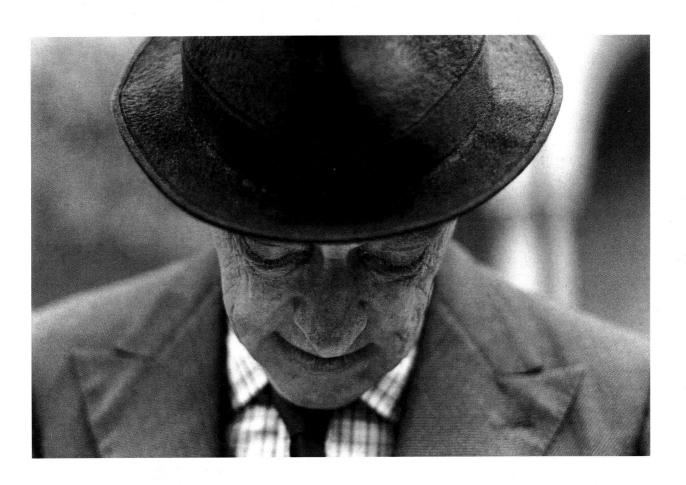

Ferdinando Scianna, Italy, *Italie,* Italien, 1984. SAUL BELLOW.

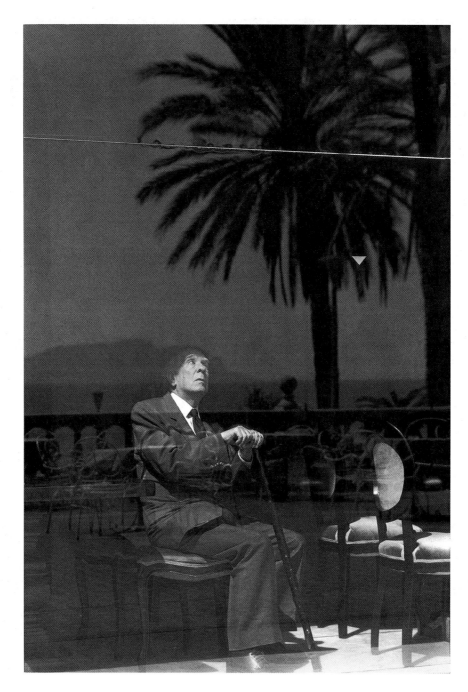

Ferdinando Scianna, Italy, *Italie,* Italien, 1984. JORGE LUIS BORGES.

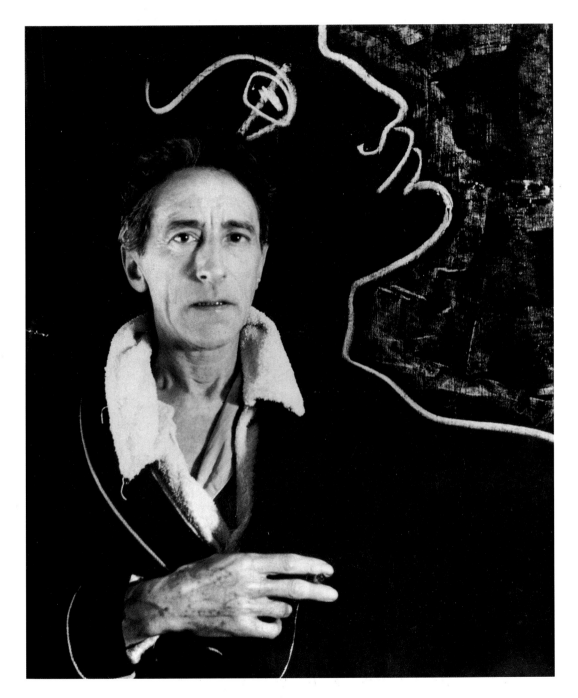

Herbert List, *France,* Frankreich, 1944. Jean Cocteau. **17**

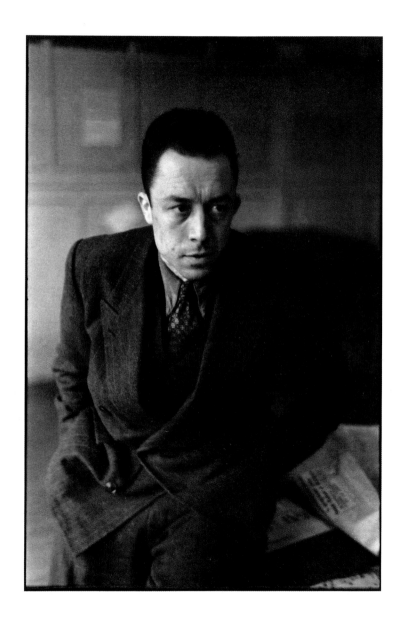

18 | Henri Cartier-Bresson, *France,* Frankreich, circa 1945, *vers 1945,* um 1945. ALBERT CAMUS.

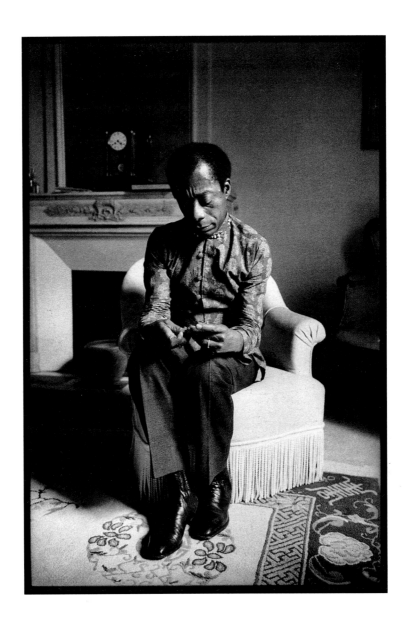

Guy Le Querrec, *France,* Frankreich, 1970. JAMES BALDWIN.

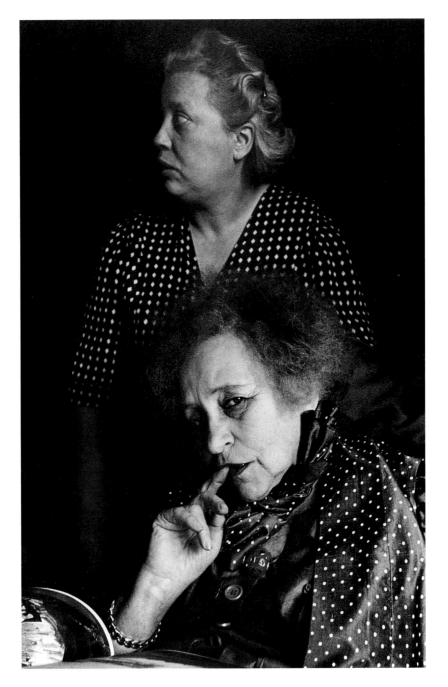

Henri Cartier-Bresson, *France,* Frankreich, 1952. Colette. **21**

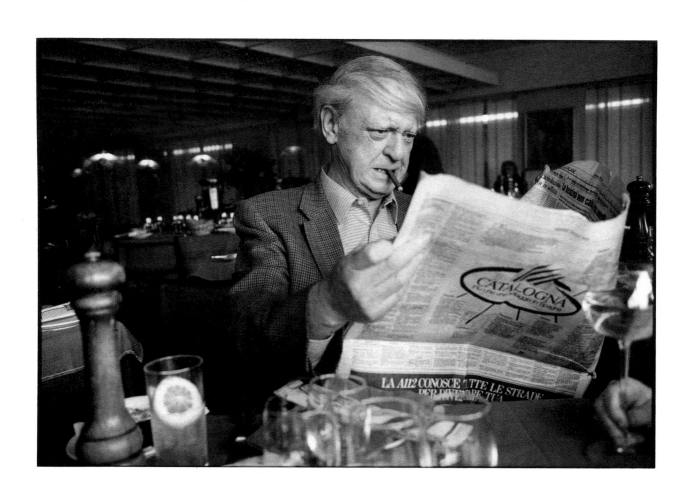

| Martine Franck, Monaco, *Principauté de Monaco,* 1985. ANTHONY BURGESS.

Ferdinando Scianna, Spain, *Espagne,* Spanien, 1996. MANUEL VAZQUEZ-MONTALBAN. **23**

| Harry Gruyaert, Morocco, *Maroc,* Marokko, 1987. MOHAMED CHOUKRI.

Raymond Depardon, *France,* Frankreich, 1990. JEAN-MARIE LE CLÉZIO.

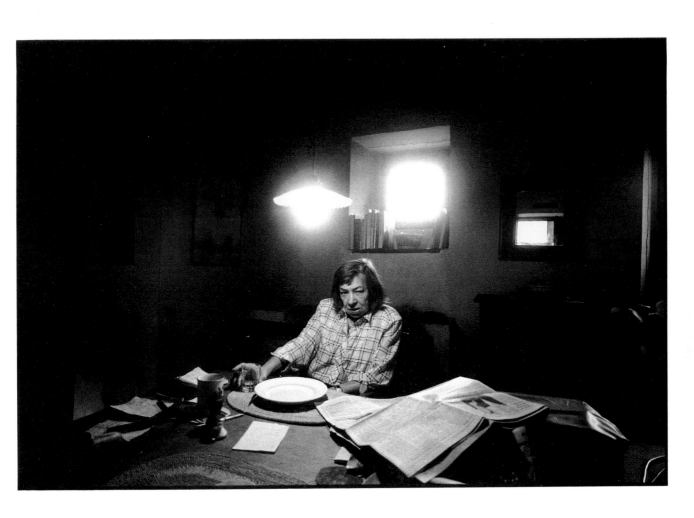

René Burri, Switzerland, *Suisse,* Schweiz, 1988. Patricia Highsmith. | **27**

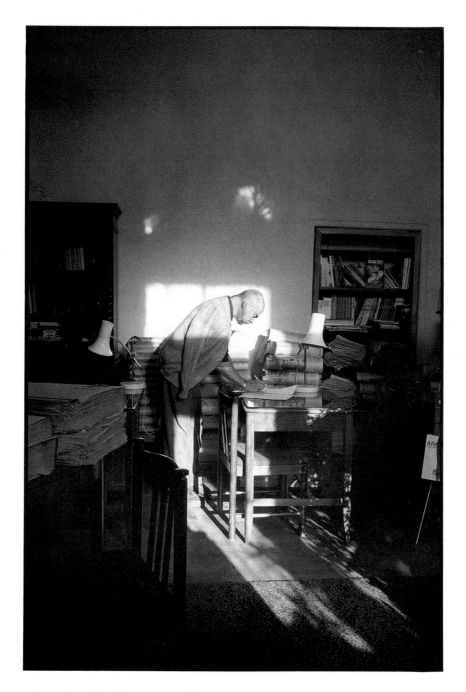

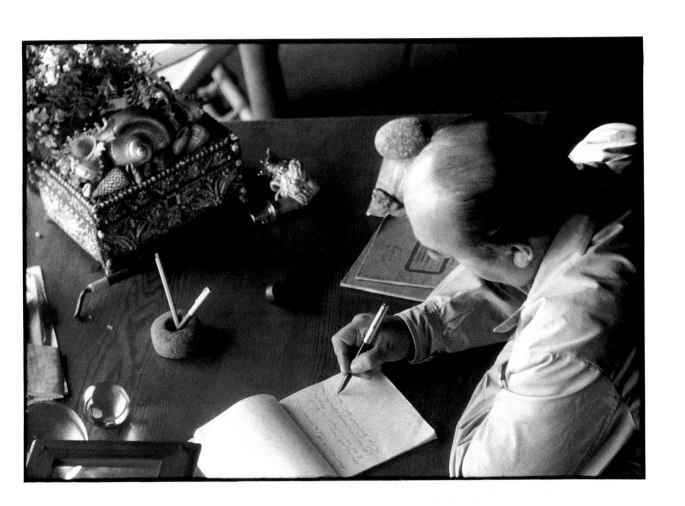

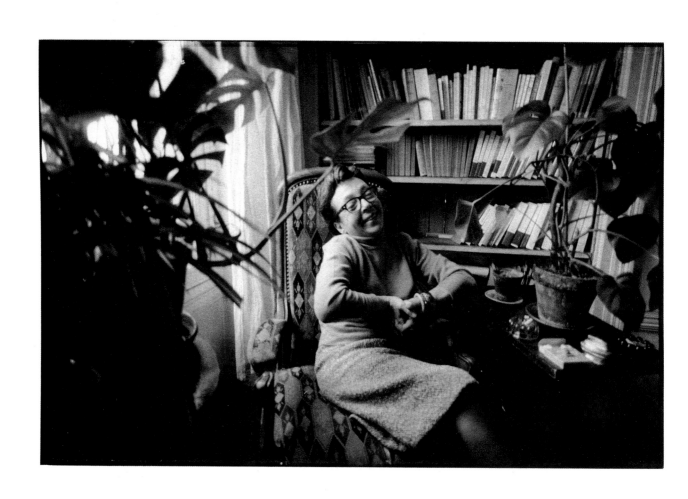

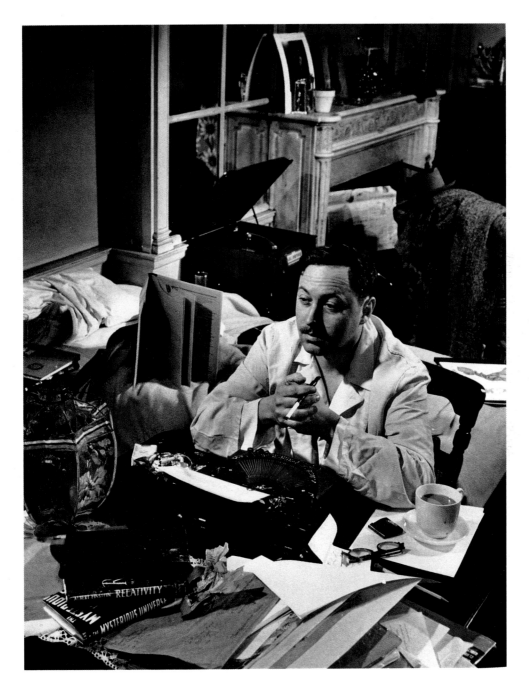

W. Eugene Smith, USA, *États-Unis,* 1948. Tennessee Williams.

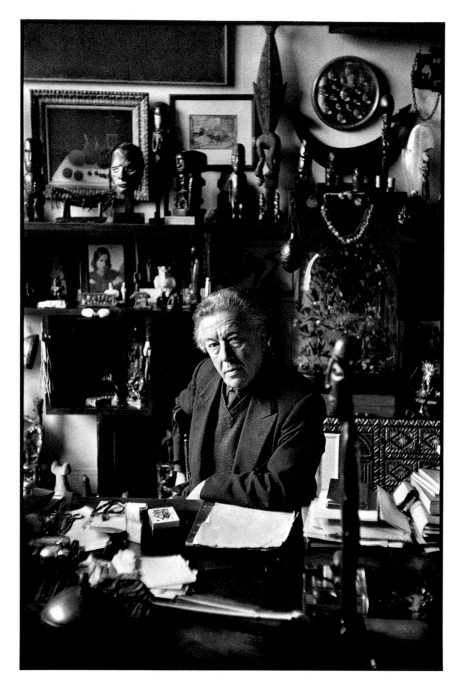

| Burt Glinn, *France,* Frankreich, 1958. ANDRÉ BRETON.

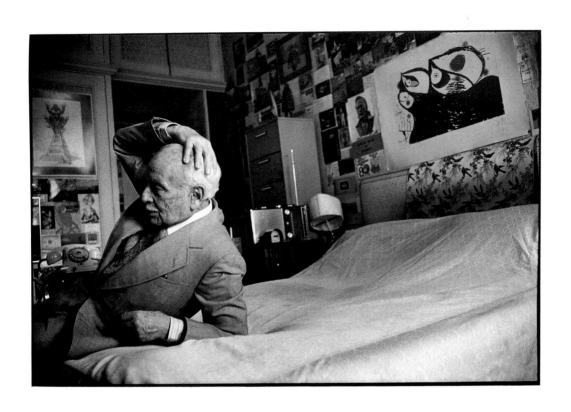

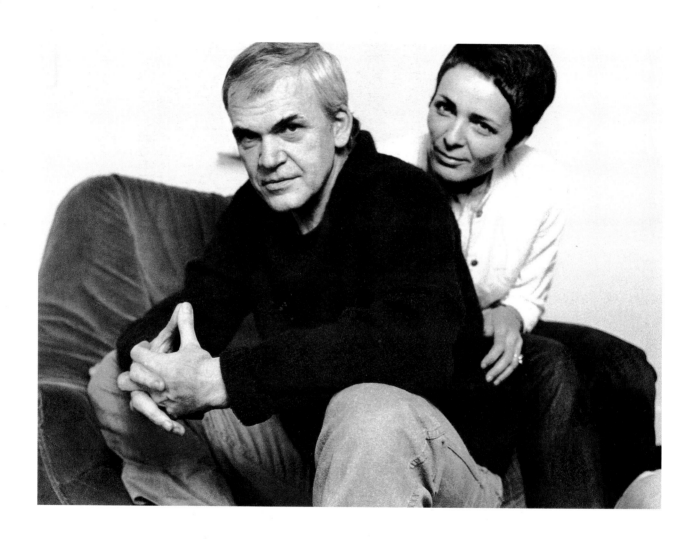

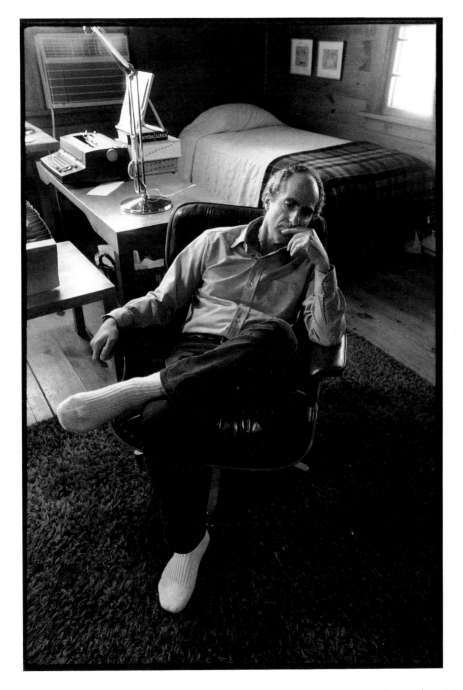

Elliott Erwitt, USA, *États-Unis*, 1990. Philip Roth.

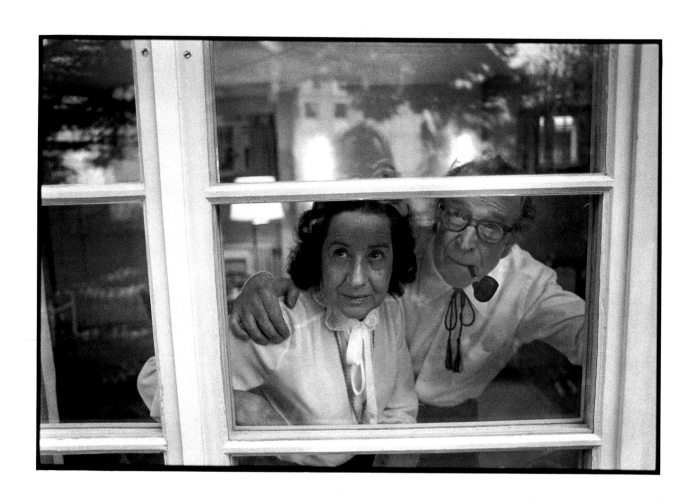

| René Burri, Switzerland, *Suisse,* Schweiz, 1982. GEORGES SIMENON.

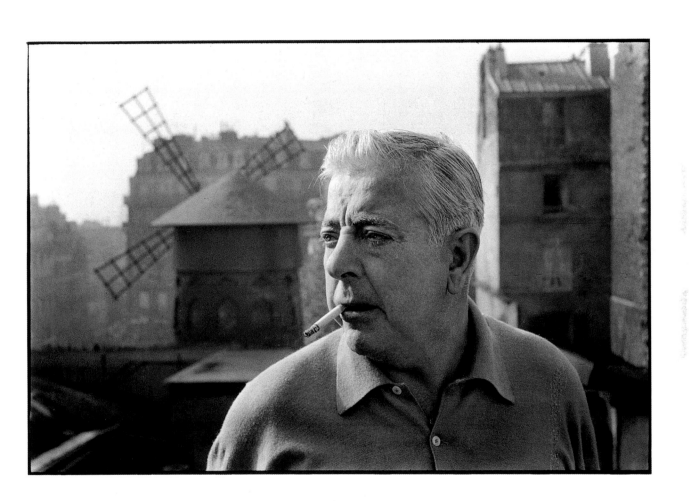

René Burri, *France,* Frankreich, 1956. JACQUES PRÉVERT. **37**

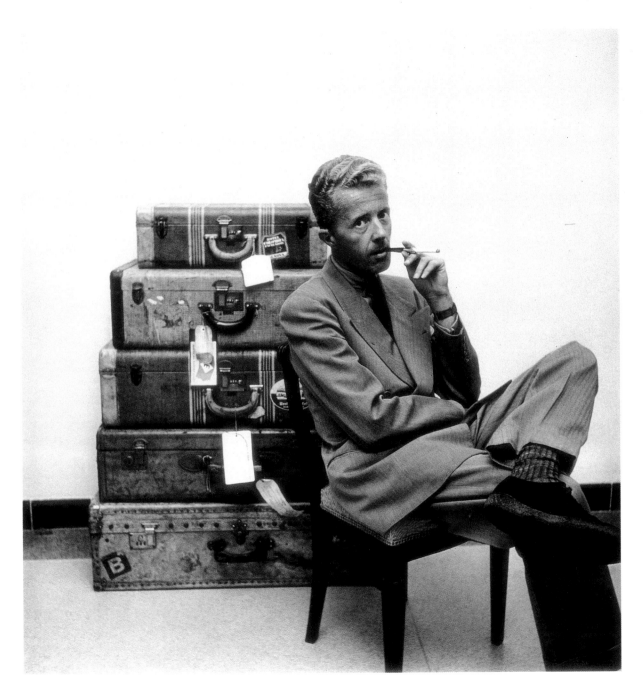

Dennis Stock, Morocco, *Maroc,* Marokko, 1952. PAUL BOWLES.

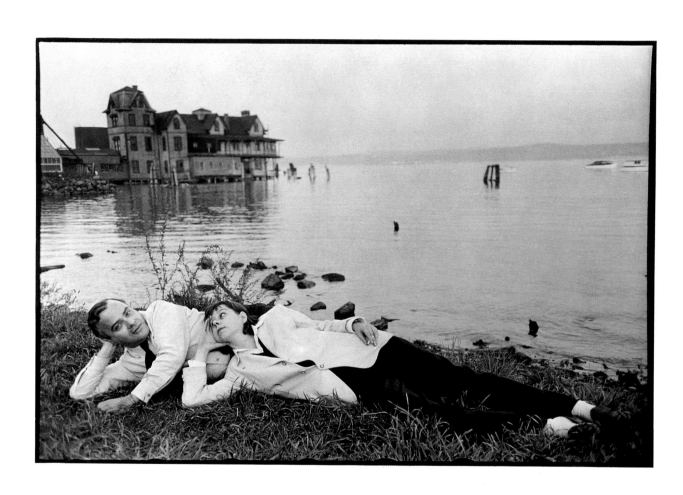

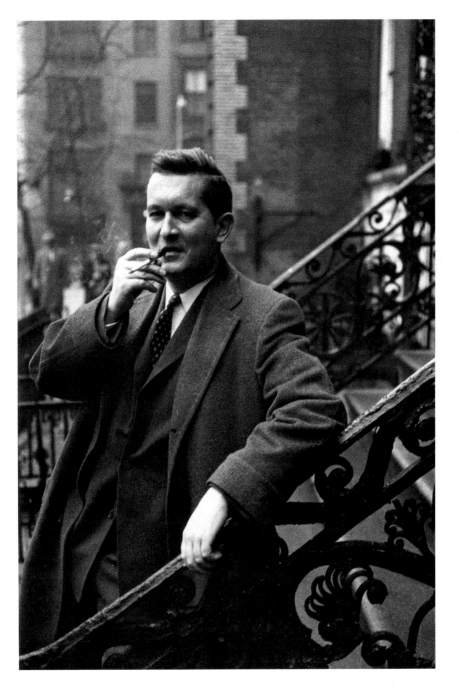

Bruce Davidson, USA, *États-Unis,* 1959. WILLIAM STYRON.

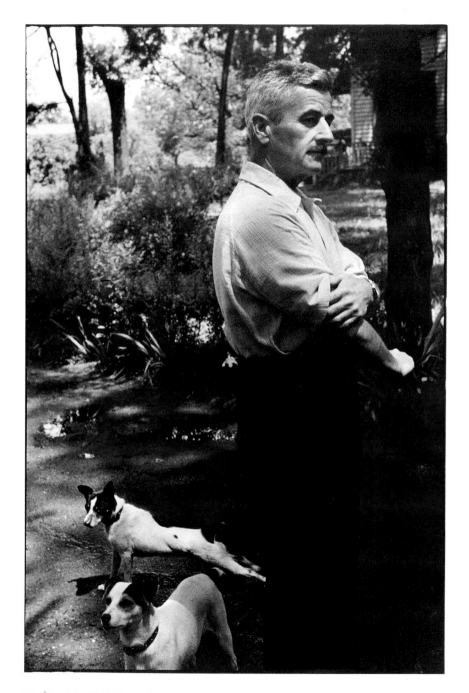

Henri Cartier-Bresson, USA, *États-Unis,* 1946. WILLIAM FAULKNER.

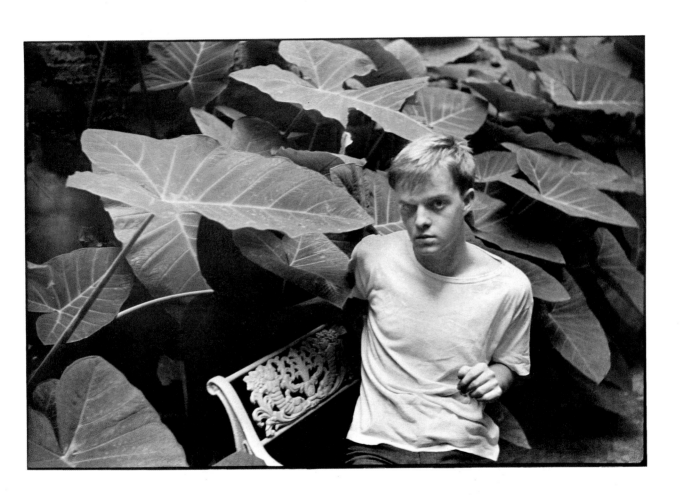

Henri Cartier-Bresson, USA, *États-Unis*, 1946. TRUMAN CAPOTE. **43**

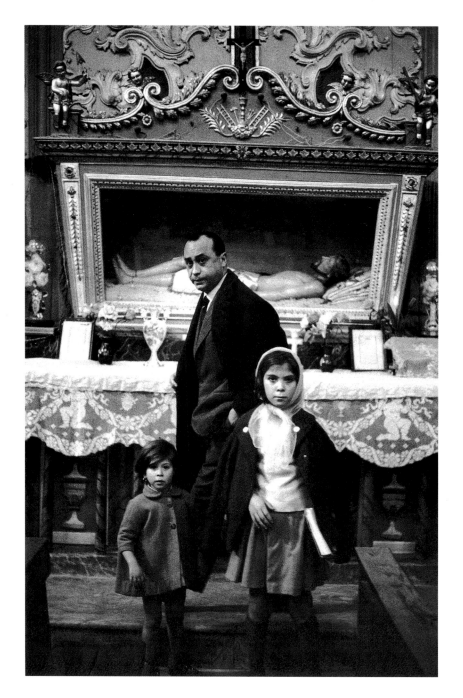

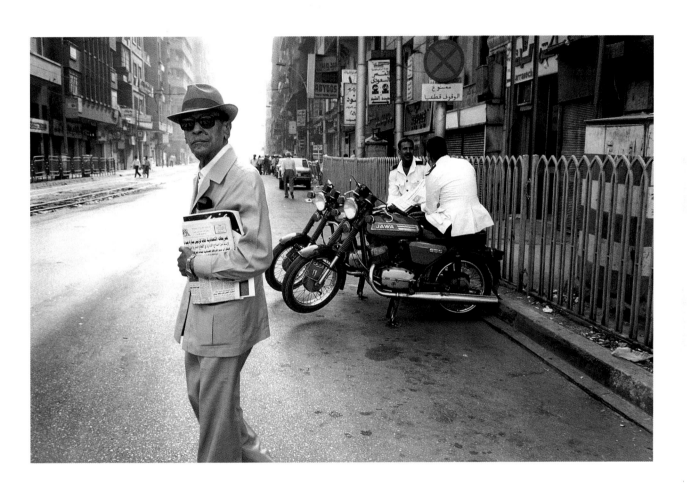

Chris Steele-Perkins, Egypt, *Égypte,* Ägypten, 1989. Naguib Mahfouz, Nagib Machfus. **45**

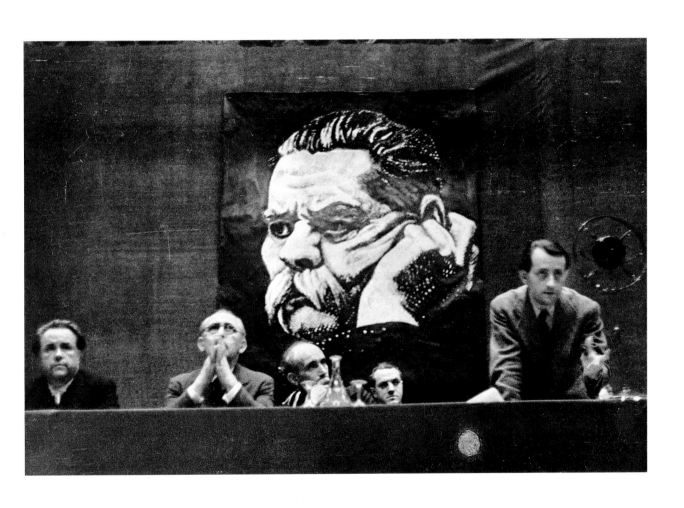

David Seymour, *France*, Frankreich, 1935. André Malraux (on the right, *à droite*, rechts). **47**

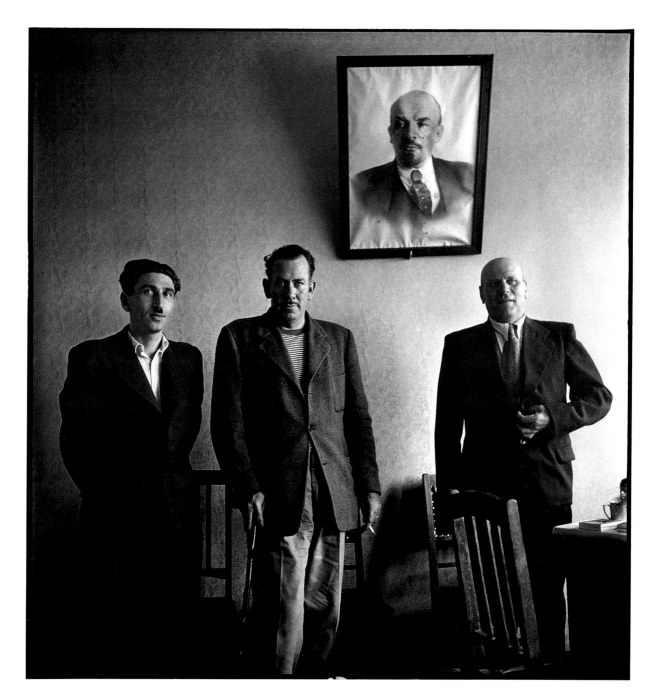

| Robert Capa, USSR, *URSS,* UdSSR, 1947. JOHN STEINBECK (in the middle, *au centre,* **in der Mitte**).

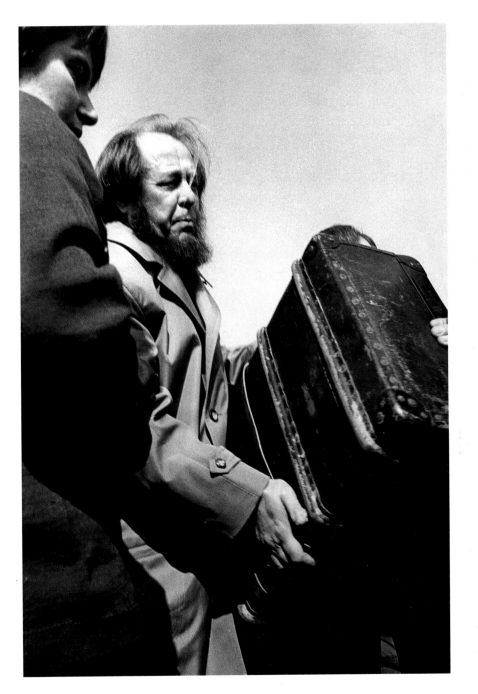

Willy Spiller, Switzerland, *Suisse*, Schweiz, 1974. ALEXANDER SOLZHENITSYN, *ALEXANDRE SOLJENITSYNE*, ALEXANDER SOLSCHENIZYN. **49**

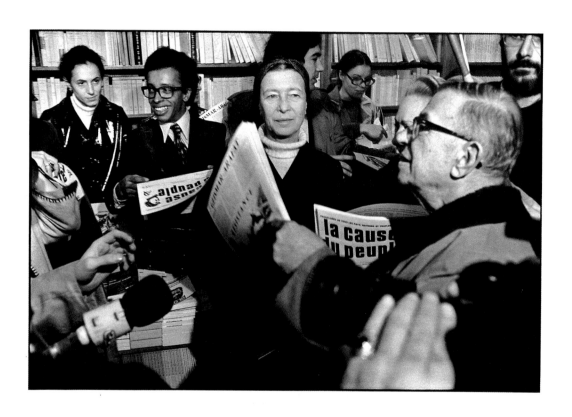

Bruno Barbey, *France,* Frankreich, October 1970, *octobre 1970,* Oktober 1970. Simone de Beauvoir.

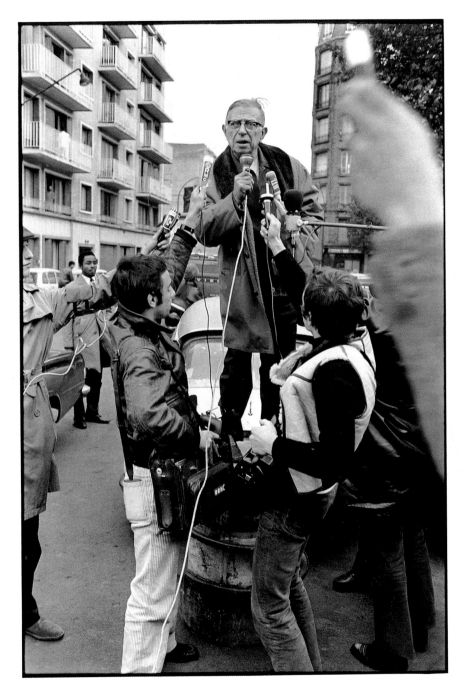

Bruno Barbey, *France*, Frankreich, October 1970, *octobre 1970*, Oktober 1970. Jean-Paul Sartre. **51**

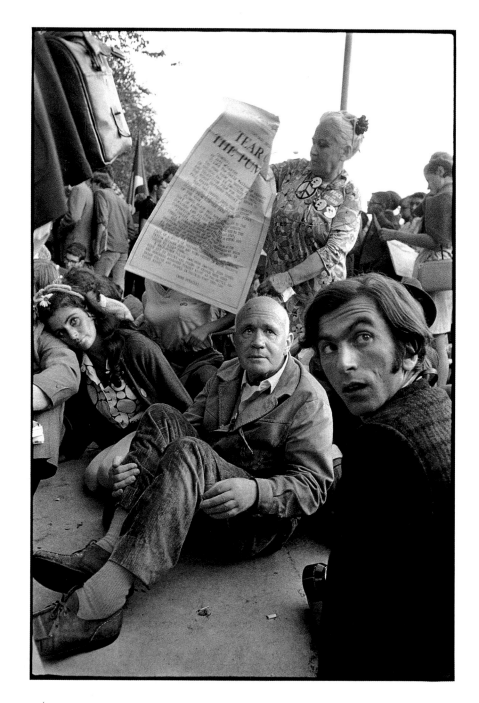

| Raymond Depardon, USA, *États-Unis,* August 1968, *août 1968.* JEAN GENET.

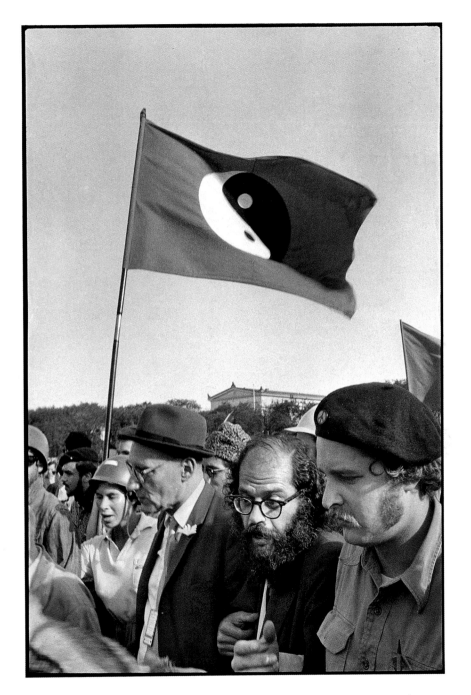

Roger Malloch, USA, *États-Unis,* 1968. ALLEN GINSBERG. | **53**

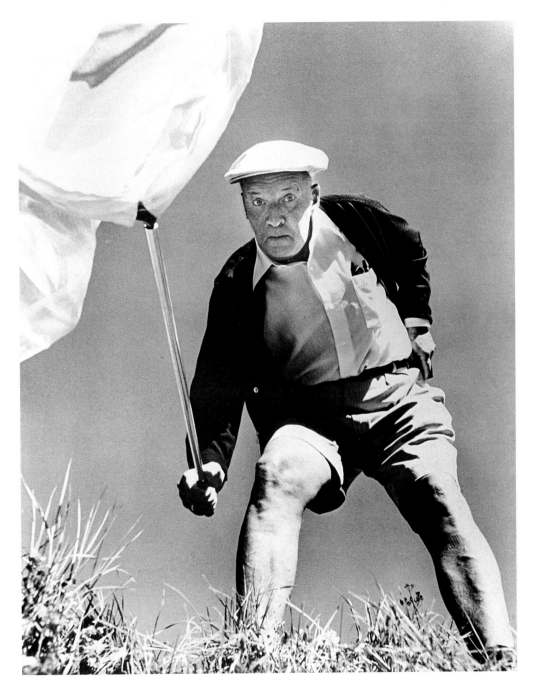

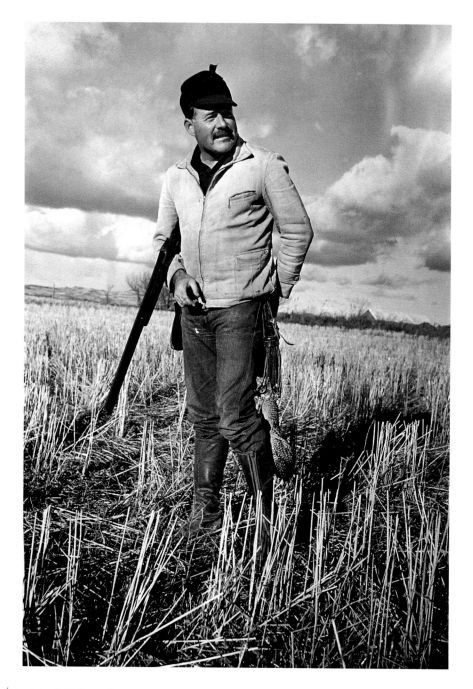

Robert Capa, USA, *États-Unis*, 1940. ERNEST HEMINGWAY.

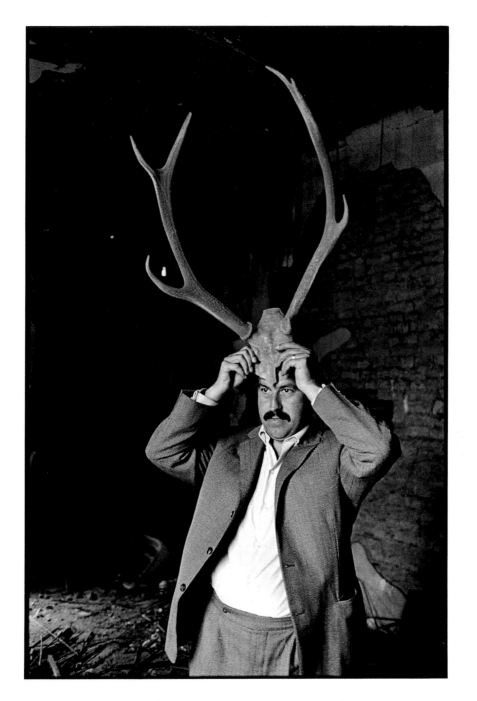

René Burri, Federal Republic of Germany, *RFA,* Bundesrepublik Deutschland, 1961. Günter Grass.

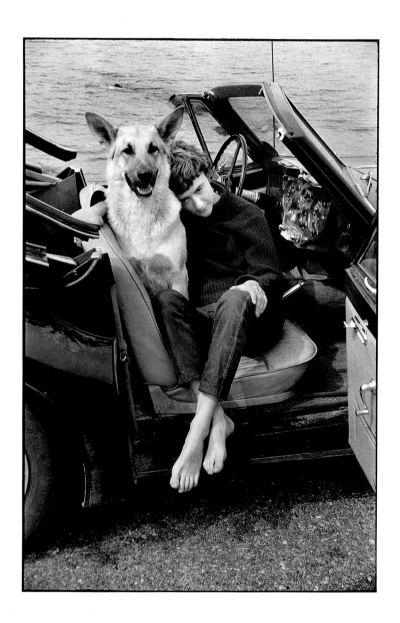

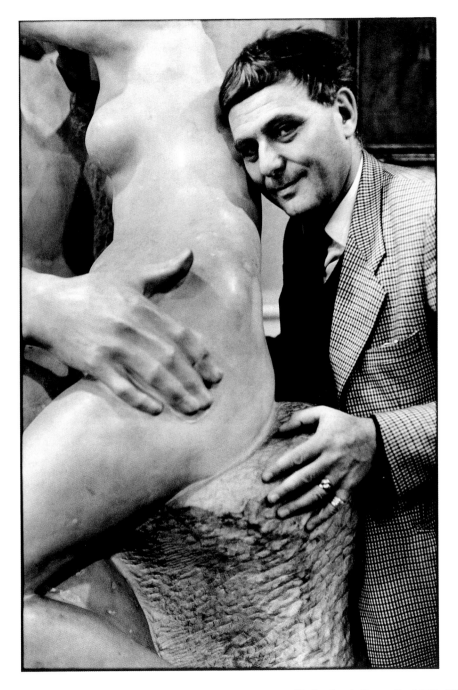

Martine Franck, *France,* Frankreich, 1986. Philippe Sollers. **59**

Henri Cartier-Bresson, *France,* Frankreich, 1951. Paul Claudel. **61**

Page 30: MARGUERITE DURAS at her home in Rue Saint Benoît, Saint Germain des Prés quarter. Paris, France. Bruno Barbey, 1965.
Page 30 : *MARGUERITE DURAS à son domicile rue Saint-Benoît, quartier Saint-Germain-des-Prés à Paris. France. Bruno Barbey, 1965.*
Seite 30: MARGUERITE DURAS in ihrer Wohnung der Rue Saint Benoît, im Viertel Saint-Germain-des-Prés, Paris. Frankreich. Bruno Barbey, 1965.

Page 31: TENNESSEE WILLIAMS, for the Broadway first night of "A Streetcar Named Desire". New York, USA. W. Eugene Smith, 1948.
Page 31 : *TENNESSEE WILLIAMS pour la première à Broadway, de Un tramway nommé désir. New York, États-Unis. W. Eugene Smith, 1948.*
Seite 31: TENNESSEE WILLIAMS anläßlich der Erstaufführung am Broadway von „Endstation Sehnsucht". New York, USA. W. Eugene Smith, 1948.

Page 32: ANDRÉ BRETON in his Montmartre flat. Paris, France. Burt Glinn, 1958.
Page 32 : *ANDRÉ BRETON dans son appartement de Montmartre. Paris, France. Burt Glinn, 1958.*
Seite 32: ANDRÉ BRETON in seiner Wohnung am Montmartre. Paris, Frankreich. Burt Glinn, 1958.

Page 33: LOUIS ARAGON in his flat. Paris, France. Martine Franck, 1978.
Page 33 : *LOUIS ARAGON dans son appartement. Paris, France. Martine Franck, 1978.*
Seite 33: LOUIS ARAGON in seiner Wohnung. Paris, France. Martine Franck, 1978.

Page 34: MILAN KUNDERA with his wife. Paris, France. Ferdinando Scianna, 1981.
Page 34 : *MILAN KUNDERA et sa femme. Paris, France. Ferdinando Scianna, 1981.*
Seite 34: MILAN KUNDERA und seine Frau. Paris, Frankreich. Ferdinando Scianna, 1981.

Page 35: PHILIP ROTH at home. Connecticut, USA. Elliott Erwitt, 1990.
Page 35 : *PHILIP ROTH chez lui, Connecticut. États-Unis. Elliott Erwitt, 1990.*
Seite 35: PHILIP ROTH in seinem Haus, Connecticut, USA. Elliott Erwitt, 1990.

Page 36: GEORGES SIMENON at home with his wife Teresa. Lausanne, Switzerland. René Burri, 1982.
Page 36 : *GEORGES SIMENON avec Teresa, son épouse, chez lui. Lausanne, Suisse. René Burri, 1982.*
Seite 36: GEORGES SIMENON mit seiner Frau Teresa bei sich zu Haus. Lausanne, Schweiz. René Burri, 1982.

Page 37: JACQUES PRÉVERT on his terrace of his home in the XVIIIth arrondissement. Paris, France. René Burri, 1956.
Page 37 : *JACQUES PRÉVERT sur la terrasse de son domicile dans le XVIIIᵉ arrondissement. Paris, France. René Burri, 1956.*
Seite 37: JACQUES PRÉVERT auf der Terrasse seiner Wohnung im 18. Arrondissement. Paris, France. René Burri, 1956.

Page 39: PAUL BOWLES embarking for France. Tangiers, Morocco. Dennis Stock, 1952.
Page 39 : *PAUL BOWLES embarquant pour la France. Tanger, Maroc. Dennis Stock, 1952.*
Seite 39: PAUL BOWLES schifft sich nach Frankreich ein. Tanger, Marokko. Dennis Stock, 1952.

Page 40: GEORGE DAVIS and Carson McCullers. New York, USA. Henri Cartier-Bresson, 1946.
Page 40 : *GEORGE DAVIS et Carson McCullers. New York, États-Unis. Henri Cartier-Bresson, 1946.*
Seite 40: GEORGE DAVIS und Carson McCullers. New York, USA. Henri Cartier-Bresson, 1946.

Page 41: WILLIAM STYRON. New York, USA. Bruce Davidson, 1959.
Page 41 : *WILLIAM STYRON. New York, États-Unis. Bruce Davidson, 1959.*
Seite 41: WILLIAM STYRON. New York, USA. Bruce Davidson, 1959.

Page 42: WILLIAM FAULKNER at his home in Oxford. Mississippi, USA. Henri Cartier-Bresson, 1946.
Page 42 : *WILLIAM FAULKNER à son domicile d'Oxford. Mississippi, États-Unis. Henri Cartier-Bresson, 1946.*
Seite 42: WILLIAM FAULKNER in seinem Haus von Oxford. Mississippi, USA. Henri Cartier-Bresson, 1946.

Page 43: TRUMAN CAPOTE. Louisiana, USA. Henri Cartier-Bresson, 1946.
Page 43 : *TRUMAN CAPOTE. Louisiane, États-Unis. Henri Cartier-Bresson, 1946.*
Seite 43: TRUMAN CAPOTE. Louisiane, USA. Henri Cartier-Bresson, 1946.

Page 44: LEONARDO SCIASCIA. Racalmuto, Sicily, Italy. Ferdinando Scianna, 1963.
Page 44 : *LEONARDO SCIASCIA. Racalmuto, Sicile, Italie.*
Ferdinando Scianna, 1963.
Seite 44: LEONARDO SCIASCIA. Racalmuto, Sizilien, Italien. Ferdinando Scianna, 1963.

Page 45: NAGUIB MAHFOUZ. Cairo, Egypt. Chris Steele-Perkins, 1989.
Page 45 : *NAGUIB MAHFOUZ. Le Caire, Égypte. Chris Steele-Perkins, 1989.*
Seite 45: NAGIB MACHFUS. Kairo, Ägypten. Chris Steele-Perkins, 1989.

Page 47: Writers' congress in defence of culture; left to right: PAUL VAILLANT-COUTURIER, ANDRÉ GIDE, JEAN-RICHARD BLOCH, ANDRÉ MALRAUX. Paris, France. David Seymour, 1935.
Page 47 : *Congrès des écrivains pour la défense de la culture ; de gauche à droite : PAUL VAILLANT-COUTURIER, ANDRÉ GIDE, JEAN-RICHARD BLOCH, ANDRÉ MALRAUX. Paris, France. David Seymour, 1935.*
Seite 47: Schriftstellerkongreß zur Verteidigung der Kultur; von links nach rechts: PAUL VAILLANT-COUTURIER, ANDRÉ GIDE, JEAN-RICHARD BLOCH, ANDRÉ MALRAUX. Paris, Frankreich. David Seymour, 1935.

Page 48: JOHN STEINBECK under Lenin's portrait. Kiev, USSR. Robert Capa, 1947.
Page 48 : *JOHN STEINBECK sous le portrait de Lénine. Kíev, URSS. Robert Capa, 1947.*
Seite 48: JOHN STEINBECK unter dem Porträt Lenins. Kiev, UdSSR. Robert Capa, 1947.

Page 49: ALEXANDER SOLZHENITSYN. Zurich, Switzerland. Willy Spiller, 1974.
Page 49 : *ALEXANDRE SOLJENITSYNE. Zurich, Suisse. Willy Spiller, 1974.*
Seite 49: ALEXANDER

SOLSCHENIZYN. Zürich, Schweiz.
Willy Spiller, 1974.

Page 50: SIMONE DE BEAUVOIR
during the press conference held
by Jean-Paul Sartre at the
printers of La cause du peuple.
Paris, France.
Bruno Barbey, October 1970.
Page 50 : *SIMONE DE BEAUVOIR
au cours de la conférence de
presse tenue par Jean-Paul
Sartre à l'imprimerie de La
cause du peuple. Paris, France.
Bruno Barbey, octobre 1970.*
Seite 50: SIMONE DE BEAUVOIR
auf der von Jean Paul-Sartre
in der Druckerei von
„La cause du peuple"
gehaltenen Pressekonferenz.
Paris, Frankreich.
Bruno Barbey, Oktober 1970.

Page 51: JEAN-PAUL SARTRE
in front of the Renault factory
in Boulogne-Billancourt.
Paris, France.
Bruno Barbey, October 1970.
Page 51 : *JEAN-PAUL SARTRE
devant les usines Renault
à Boulogne-Billancourt.
Paris, France.
Bruno Barbey, octobre 1970.*
Seite 51: JEAN-PAUL SARTRE
vor den Renault-Werken in
Boulogne-Billancourt.
Paris, Frankreich.
Bruno Barbey, Oktober 1970.

Page 52: JEAN GENET during
demonstrations against the
Vietnam War at the Democrat
Convention.
Chicago, Illinois, USA.
Raymond Depardon, August
1968.
Page 52 : *JEAN GENET au cours
des manifestations contre la
guerre au Vietnam pendant la
convention nationale du parti
démocrate.
Chicago, Illinois, États-Unis.
Raymond Depardon, août 1968.*
Seite 52: JEAN GENET auf einer
Demonstration gegen den
Vietnamkrieg während des

Parteitags der Demokraten.
Chicago, Illinois, USA.
Raymond Depardon,
August 1968.

Page 53: ALLEN GINSBERG
during a demonstration against
the Vietnam War at the
Democrat Convention.
Chicago, Illinois, USA.
Roger Malloch, 1968.
Page 53 : *ALLEN GINSBERG
lors d'une manifestation contre
la guerre au Vietnam pendant
la convention nationale
du parti démocrate.
Chicago, Illinois, États-Unis.
Roger Malloch, 1968.*
Seite 53: ALLEN GINSBERG auf
einer Demonstration gegen den
Vietnamkrieg während des
Parteitags der Demokraten.
Chicago, Illinois, USA.
Roger Malloch, 1968.

Page 55: VLADIMIR NABOKOV.
Montreux, Switzerland.
Philippe Halsman, 1968.
Page 55 : *VLADIMIR NABOKOV.
Montreux, Suisse.
Philippe Halsman, 1968.*
Seite 55: VLADIMIR NABOKOV.
Montreux, Schweiz.
Philippe Halsman, 1968.

Page 56: ERNEST HEMINGWAY.
Sun Valley, Idaho, USA.
Robert Capa, 1940.
Page 56 : *ERNEST HEMINGWAY.
Sun Valley, Idaho, États-Unis.
Robert Capa, 1940.*
Seite 56: ERNEST HEMINGWAY.
Sun Valley, Idaho, USA.
Robert Capa, 1940.

Page 57: GÜNTER GRASS.
West Berlin,
Federal Republic of Germany.
René Burri, 1961.
Page 57 : *GÜNTER GRASS.
Berlin-Ouest, RFA.
René Burri, 1961.*
Seite 57: GÜNTER GRASS.
Westberlin,
Bundesrepublik Deutschland.
René Burri, 1961.

Page 58: FRANÇOISE SAGAN.
Saint-Tropez, France.
David Seymour, 1956.
Page 58 : *FRANÇOISE SAGAN.
Saint-Tropez, France.
David Seymour, 1956.*
Seite 58: FRANÇOISE SAGAN.
Saint-Tropez, Frankreich.
David Seymour, 1956.

Page 59: PHILIPPE SOLLERS
at the Musée Rodin.
Paris, France.
Martine Franck, 1986.
Page 59 : *PHILIPPE SOLLERS
au musée Rodin.
Paris, France.
Martine Franck, 1986.*
Seite 59: PHILIPPE SOLLERS
im Musée Rodin.
Paris, Frankreich.
Martine Franck, 1986.

Page 61: PAUL CLAUDEL
at Brangues. Isère, France.
Henri Cartier-Bresson, 1951.
Page 61 : *PAUL CLAUDEL à
Brangues. Isère, France.
Henri Cartier-Bresson, 1951.*
Seite 61: PAUL CLAUDEL in
Brangues. Isère, Frankreich.
Henri Cartier-Bresson, 1951.